*Boosting Self-Esteem
in Children and Adolescents*

A Manual
for Parents, Teachers
and Guardians

Essays and articles by
Charles Mak, Meredith Resnick, Irene S. Levine, Stanley J. Gross, Michelle New, D'Arcy Lyness, Carl E. Pickhardt, John M. Grohol, Jae Song & Tina Su, and Lisa (Think Simple)

Boosting Self-Esteem
in Children and Adolescents

A Manual for Parents, Teachers and Guardians
Edited by Wendy Cope

Articles by

Charles Mak
Meredith Resnick
Irene S. Levine
Stanley J. Gross
Michelle New
D'Arcy Lyness
Carl E. Pickhardt
John M. Grohol
Jae Song & Tina Su
Lisa (Think Simple)

For Each Individual Author here Anthologized:
All Rights Reserved© 2014/2017

Third Edition 2017
Edited by Wendy Cope
London / New York

Ideated by Ermes Lorena © 1997-99
Creative Commons ©©
Right to Inform

Index of Contents

SELF-CONCEPT..4
HOW TO RAISE SELF-ESTEEM..14
10 COMMITMENTS THAT WILL MAKE YOU A BETTER PARENT...19
IT IS IMPORTANT TO LIKE ONESELF..31
TEENAGERS AND SELF-ESTEEM...34
MORE STEPS TO IMPROVING SELF-ESTEEM..........................38
HOW PARENTS CAN HELP..41
NARCISSISM..45
NARCISSISM: SURVIVING THE SELF-INVOLVED....................46
FINDING PROFESSIONAL HELP..49
A POSITIVE IMAGE: SELF-ESTEEM...50
TEACH ADOLESCENTS HOW TO MAINTAIN HEALTHY SELF-ESTEEM..54
6 TIPS TO IMPROVE SELF-ESTEEM..61
13 MORE TIPS TO BUILDING SELF-ESTEEM.........................68
THE SECRET TO SELF LOVING: WHAT SHOULD I DO WITH MY LIFE?..80
APPENDIX...85
THE IMPORTANCE AND EXTENSIVENESS OF THE TOPIC......86
AN ADAPTATION OF FREUD'S EGO-DEFENSE MECHANISMS TO SELF-ESTEEM ISSUES..89
BIBLIOGRAPHY..93

Self-Concept

By C. Seefeldt

"I'm not big now, but I'm growing. I can ride a bike and run and jump and skip, and next year I'll learn to read, too," answers Domingo when asked to tell about himself. Domingo's answer reveals his attitude about himself—not very big but growing, an "I can do" attitude, and an attitude that says, "I will grow, I will learn, I can do it!"

Self-esteem, self-identity, and self-concept—educators use these terms to denote the totality of meanings, feelings, and attitudes that children maintain about themselves. Self-concept refers to cognitive activity: children's awareness of their own characteristics and of likenesses and differences between themselves and others (Marsh, Craven, & Debus, 1998). Self-esteem refers to children's regard for and feelings about themselves. Self-identity has a social connotation; it includes awareness of group membership.

Whatever definition or terminology they use, scholars have long recognized the importance of feelings of self-esteem in human behavior. As a theoretical construct, the self has been an object of interest since the 17th century, when René Descartes (1646) first discussed the cogito, or self, as a thinking substance. Throughout the ages, prominent theorists and researchers have recognized the importance of feelings of self-esteem in human behavior. Theories of Sigmund Freud (1949), Carl Rogers (1961), Abraham Maslow (1969), and others have been directed toward understanding the conduct of human beings by

examining the feelings and beliefs that individuals hold about themselves.

The theories of these scholars differ greatly. However, amid the diversity, some assumptions are basic to all theories of self. One assumption is that self-esteem begins to be established early in life and is modified and shaped by the children's succession of experiences with significant people in their environment. Another assumption present in all theories of self is that self-esteem has a predictable effect on behavior. The theories also hold that self-concept, self-esteem, or self-identity is multifaceted: children's self-concepts about their social, academic, physical, and other facets may differ (Marsh et al., 1998).

Finally, theories of the self generally agree that an early childhood program can foster children's self-esteem and build the foundation for future relationships with others (NICHD Early Childcare Research Network, 1998). Teachers can structure the classroom and respond to children in ways that contribute to their feelings of general identity, their physical and academic self-competence.

General Identity: Names

People's names make them unique. Using children's names in the classroom fosters their sense of esteem. When you use a child's name, you are saying, "I know you, and I respect you." Teachers may encourage children not only to call one another by name but also to use the names of teachers, volunteers, and assistants. In this way, children learn that each person is an important individual and that each is different from the other.

"I can't say my last name, but I can show it to you," says Michael, leading the teacher to a piece of plaid fabric, mounted and framed. "My last name begins with Mc, and that's my sign." First names come naturally to the children and teacher, yet you do not want to neglect children's family names. Children might, as Michael did, find out the history of their last names, the places on the map where the names originated, or what they mean.

Very young children might be encouraged to learn their parents' first names. Understanding that their mothers and fathers have their own names helps children see their parents as people in their own right. In the classroom, you might do the following:

- Use children's names in songs, and substitute their names in stories, poems, and games.
- Write the children's names on objects that belong to them.
- Make up news stories using the children's names: "Susan has new shoes. They are brown."
- Purchase a stamp pad and rubber stamps with the children's names individually imprinted on each. Children just learning to read their names enjoy these stamps.
- Place two stacks of name cards on the game table for the children to play with. Children can sort through them and find their own name, all the names they can read, or any names that are alike. Depending on their age, they can classify the name cards according to boys, girls, friends, or initial or final sounds.
- Take snapshots of the children, and mount them on cards with their names. As the children

become familiar with the pictures and names, cut the names from the cards. Then the children can match the names with the pictures.

- Make bulletin boards using children's names. One might be, "We are in kindergarten. There are 15 children," with the children's self-portraits and names below.
- Make a name picture book. Place a photo of each child on a page. Then the child or you writes her name under the photo and a sentence about what she likes.

What is self-esteem?

By Michelle New

You can't touch it, but it affects how you feel. You can't see it, but it might be there when you look at yourself in the mirror. You can't hear it, but it's there when you talk about yourself or when you think about yourself.

What is this important but mysterious thing? It's your self-esteem!

Self-esteem can have a big part to play in how you feel about yourself and also how much you enjoy things or worry about things.

To understand self-esteem, it helps to break the term into two words. Let's first take a look at the word *esteem*, which means that someone or something is important, special, or valuable.

For example, if you really admire your friend's dad because he volunteers at the fire department, it means you hold him in high esteem. And the special trophy for the most valuable player on a team is often called an esteemed trophy. This means the trophy stands for an important accomplishment.

And self means, well, yourself! So put the two words together and it's easier to see what self-esteem is. It's how much you value yourself and how important you think you are. It's how you see yourself and how you feel about the things you can do.

Self-esteem isn't about bragging, it's about getting to know what you are good at and not so good at.

A lot of us think about how much we like other people or things, but don't really think much about whether we like ourselves.

It's not about thinking you're perfect, because nobody is perfect. Even if you think some other kids are good at everything, you can be sure they have things they're good at and things that are difficult for them.

The most important thing to know about self-esteem is that it means seeing yourself in a positive way that's realistic, which means that it's the truth.

So if you know you're really good at piano but can't draw so well, you can still have great self-esteem!

Why Self-Esteem Is Important

Self-esteem isn't like a cool pair of sneakers you really want but can wait until your next birthday to get. All kids have self-

esteem, and having healthy or positive self-esteem is really important.

It can help you hold your head high and feel proud of yourself and what you can do, even when things don't seem to be going so well.

Self-esteem gives you the courage to try new things and the power to believe in yourself. It lets you respect yourself, even when you make mistakes. And when you respect yourself, adults and other kids usually respect you, too.

Having positive self-esteem can also help you can learn to make healthy choices about your mind and body. If you think you're important, you'll be less likely to follow the crowd if your friends are doing something wrong or dangerous. If you have positive self-esteem, you know you're smart enough to make your own decisions.

You value your safety, your feelings, your health — your whole self! Positive self-esteem helps you know that every part of you is worth caring for and protecting.

How Kids Get Self-Esteem

Babies don't see themselves in a good or bad way. They don't think "I'm great!" when they let out a big burp or worry "Oh, no, this diaper makes my legs look weird!"

Instead, people around a baby help him or her develop self-esteem. How? By encouraging the baby when he or she learns to crawl, walk, or talk. They often say, "Good job. Good for you!" Or, they might just smile and look proud. When people take good care of a baby, that also helps him or her feel loved and valuable.

As kids get older, they can have a bigger role in developing their own self-esteem. Working hard to finish a project or assignment, getting a higher grade on a math test, or trying out for a new sport are all things kids can be proud of for trying.

Some kids are not very athletic, but they might be good readers or know how to do magic tricks or are really good friends or help other people out — these are all accomplishments that help kids feel good about themselves.

A kid's family and other people in his or her life — like coaches, teachers, and classmates — also can boost self-esteem.

They can help a kid figure out how to do things or notice his or her good qualities.

They can believe in the kid and encourage him or her to try again when something doesn't go right the first time.

It's all part of kids learning to see themselves in a positive way, to feel proud of what they've done, and to be confident that there's a lot more they can do.

A Little on Low Self-Esteem

Maybe you know kids with low self-esteem who don't think very highly of themselves or seem to criticize themselves too much. This can also be called negative self-esteem, and it's the opposite of positive self-esteem. Maybe you have low self-esteem sometimes and don't always feel very good about yourself or think you're important.

Sometimes a kid will have low self-esteem if his mother or father doesn't encourage him enough or if there is a lot of yelling at home. Other times, a kid's self-esteem can be hurt in the classroom. A teacher or other kids might make a kid feel like he or she isn't smart, or maybe there are mean kids who say hurtful things about the way a kid looks or acts.

For some kids, classes at school can seem so hard that they can't keep up or get the grades they'd hoped for. This can make them feel bad about themselves and hurt their self-esteem. When some kids do well and win prizes and awards, other kids might feel like they're not as good or there's something wrong with them.

Some kids have positive self-esteem but then something happens in their lives to change that. For example:

- If a kid moves and doesn't make friends right away at the new school, he or she might start to feel bad and think they are not a good friend.
- Kids whose parents divorce might find that this can affect self-esteem. They may feel bad when a parent can't give them attention or come to their game, or they might feel that if they had behaved better or kept their room clean, their parents would not have split up.
- Kids who look different from other kids may not feel good about themselves because they feel "different" or someone makes fun of them.
- A kid who's dealing with an illness, such as cancer, diabetes, or asthma, might feel different and less confident than before.
- Kids who have learning differences or know they have trouble reading a book report aloud might start losing confidence and focus too much on things they're not good at.

- Even going through the body changes of puberty — something that everybody does — can affect a kid's self-esteem.

How To Raise Self-Esteem

By Stanley J. Gross

Stanley J. Gross argues that we learn self-esteem in our family of origin; we do not inherit it.

Have you wondered about what self-esteem is and how to get more of it?
Do you think that your child's self-esteem is low?
Do you know how to tell?
How does she or he feels about it?
Do you know what to do about it?

It is important to make your child receive help to stop possible self-destructive behaviours.

"Global self-esteem (about "who we are") is normally constant.

Situational self-esteem (about what we do) fluctuates, depending on circumstances, roles, and events.

Situational self-esteem can be high at one moment (e.g., at work) and low the next (e.g., at home).

Low self-esteem is a negative evaluation of oneself.

This type of evaluation usually occurs when some circumstance we encounter in our life touches on our sensitivities.

We personalize the incident and experience physical, emotional, and cognitive arousal.

This is so alarming and confusing that we respond by acting in a self-defeating or self-destructive manner.

When that happens, our actions tend to be automatic and impulse-driven; we feel upset or emotionally blocked; our thinking narrows; our self-care deteriorates; we lose our sense of self; we focus on being in control and become self-absorbed.

Global self-esteem is not set in stone. Raising it is possible, but not easy. Global self-esteem grows as we face our fears and learn from our experiences. Some of this work may require the aid of a psychotherapist. In the meantime, here is what you can do:

Addictions block learning and drag down our mood. Identify them and replace them with self-care."

Drawing on Gross's ideas, I suggest to help your child practice self-care.
Create new lifestyle choices for him or her by letting him or her join self-help groups and practice positive health care.

Gross stresses: "We personalize stressful events (e.g., criticism) by inferring a negative meaning about ourselves.
Identify triggers to low self-esteem. A self-defeating action often follows. Each event can, instead, be a chance to learn about ourselves, if we face our fear of doing so and the negative beliefs about ourselves that sustain the negative meanings."

Help your child to slow down personalizing.

"Target personalizing to slow impulsive responses.
You can begin to interfere with these automatic overreactions by using relaxation and stress management techniques. These techniques are directed at self-soothing the arousal.

This allows us to interrupt the otherwise inevitable automatic reaction and put into play a way to begin to face the unacknowledged fears at the root of low self-esteem."

Help your child to stop and take notice. He or she can learn how to pay attention to the familiarity of the impulse.

"Our tendency is to overreact in the same way to the same incident.

Awareness of the similarity can be the cue to slow our reactivity."

Teach your child to acknowledge his or her reactions: "Here I go again (describe action, feeling, thought) . . . "

Try to show your child to actively do something with this awareness rather than passively note it.

"The result is to slow the impulse and give ourselves a choice about how we want to respond."

Educate your child to

choose his or her response
hold self-defeating impulses
act in a self-caring and effective way.

Gross argues: "By choosing to act in a more functional way, we take a step toward facing our fears."

Educate your child to accept impulse and recognized the benefit (e.g., protection) of overreaction.

"We won't be able to do this at first, but as we become more effective, we will begin to appreciate what our self-defeating impulse had been doing for us."

Help your child to develop skills.

"We can provide for our own safety, engender hope, tolerate confusion, and raise self-esteem by learning and using these essential life skills.

Experience feelings.

"Feel" feelings in your body and identify your needs. When we do not respect our feelings, we are left to rely on what others want and believe."

What next?

This is what Gross suggests:

"Optional thinking. End either/or thinking. Think in "shades of gray" and learn to reframe meanings. By giving ourselves options, we open ourselves to new possibilities about how to think about our dilemmas.

 Detachment. End all abuse; say "no" to misrepresentations and assumptions. By maintaining personal boundaries, we discourage abuse by others and assert our separateness.

Assertion. Voice what you see, feel, and want by making "I" statements. By expressing our thoughts, feelings, and desires in a direct and honest manner, we show that we are in charge of our lives.

Receptivity. End self-absorption; listen to others' words and meanings to restate them. In this way, we act with awareness of our contribution to events as well as empathize with the needs of others."

10 Commitments That Will Make You a Better Parent

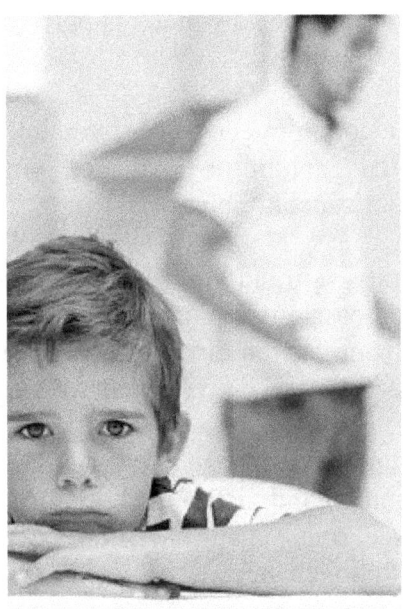

Being a parent is tough. Most of us feel like we could do a better job, but resolving to be more patient rarely works. That's because sometimes the first step to being a better parent is actually about how we treat ourselves.

We can only give what we have inside. And if we can't manage our own emotions. we can't expect our kids to learn to manage theirs.

But if you want to become a more inspired parent – and a happier person – that's completely possible. I've seen countless parents do it. How? Step by step.

Start by committing yourself.

Envision what your life will look like when you keep this commitment, and how you'll feel. Notice how much closer you feel to your child. Notice how much happier your child is, and how much more cooperative.

Revisit your commitment daily, including your image of how keeping that commitment makes you feel. (You're programming your subconscious.)

When you mess up (and you will, if you're human), offer yourself total compassion, apologize to your child, and take a positive step in your desired direction. Two steps forward, one step back still takes you where you want to go.

Make a small positive change every day. Find support (like my free daily emails) and give yourself constant cheerleading. At first you'll see small changes. But sooner or later, small changes add up to big changes.

Wondering where to begin? Here are 10 Commitments that will make you a better parent – and a happier person. Start with one, or commit to all ten. I'll be here to support you each step of the way.

1. Commit to taking care of yourself and staying centered so you can be the happy, patient, encouraging parent your child deserves. That means integrating daily sustainable self-nurturing into your life: Go to bed earlier so you're better rested, eat healthfully to maintain your mood, transform any inner negative voices into encouraging ones, and slow down your pace so you can enjoy your life. Most important of all, commit to managing yourself. When your emotions are

dysregulated, you're in fight or flight, and your child looks like the enemy. Calm yourself before you engage with your child.

2. Commit to loving the one you're with. The one thing we know for certain about child development is that kids who feel loved and cherished thrive. That doesn't mean kids who ARE loved – plenty of kids whose parents love them don't thrive. The kids who thrive are the ones who FEEL loved and cherished for exactly who they are. Every child is unique, so it takes a different approach for that child to feel seen and loved. The hard work for us as parents is accepting who our child is, warts and all – and cherishing him or her for being that person, even while guiding behavior. The secret? See it from his perspective, use a positive lens, and celebrate every step in the right direction.

3. Commit to staying connected. Separation happens. That's why we have to repeatedly reconnect. Remember that quality time is about connection, not teaching, so it's mostly unstructured. Hug your child first thing every morning and when you say goodbye. When you're reunited later in the day, spend fifteen minutes solely focused on your child. (What do you do in that 15 minutes? Listen, commiserate, hug, laugh, listen some more.)
Stop working before dinner time so you can devote your evening to your family. Eat dinner together. Have a chat and a silent snuggle at bedtime every night with each child.

4. Commit to role modelling respect. Want to raise kids who are considerate and respectful, right through the teen years? Take a deep breath, and speak to them respectfully. Not always easy when you're angry, so remember the cardinal rules of managing your emotions with kids: You're the role model, don't take it personally, and this too shall pass!

5. Commit to teaching emotional intelligence. In addition to modelling emotional self management, we help kids learn to manage their emotions by:

Teaching them to self-soothe. Contrary to what you may have heard, little ones don't learn to self-soothe by being left to cry. (That just creates an over-active amygdala and panic response later in life.) As anyone who has ever tried to calm herself down knows, soothing is a physiological process. When a baby cries and we soothe him, his body responds by sending out oxytocin and other soothing biochemicals. What you see is that he calms down. What's happening biologically is that he's solidifying the neural pathways for these self-soothing hormones. That's how he develops the ability to soothe himself when he's upset.

Giving them the message that their full range of feelings is understandable, even while their actions must be limited. ("You wish you could have a cookie")

Empathizing with their emotions.

Listening to them when they have feelings to express. Occasionally this will take the form of words, and it helps to give kids words for their feelings: "You're so mad!" But more often, children just need us to give them the safety of our loving presence while they cry or rage to vent their feelings. Often they won't be able to articulate what they're upset about, and it isn't necessary. But this helps kids learn to accept and process their emotions, so they can move past them rather than having to act on them. (That's what "acting out" means -- we act on our feelings rather than simply tolerating them as they sweep through us and dissipate.)

6. Commit to looking for the needs behind your child's behavior. Your kid has a reason for whatever he's doing that displeases you. It might not be what you consider a good reason, but it's what's motivating his behavior. If yelling at him about his behavior were going to change it, that would

have worked already. Only by addressing the underlying need do we change a person's behavior. Parents who address kids' need pre-emptively by noticing problem areas ("Hmm....looks like she wants to choose her own clothes, even if they don't match!") are rewarded with kids who cooperate.

7. Commit to guidance rather than punishment. Kids only behave to please us. When we constantly criticize and discipline, they harden their hearts to us. Parents who lead by loving example, address needs rather than focusing on misbehavior, redirect pre-emptively rather than punish ("You can throw the ball outside"), and set limits empathically ("You're mad and sad, but we don't hit. Let's use your words to tell your brother how you feel") end up with self-disciplined kids who WANT to behave.

8. Commit to remembering what's important and an attitude of gratitude. Stay positive and choose your battles. Every negative interaction with your child uses up valuable relationship capital. Focus on what matters, such as the way your child treats her siblings. In the larger scheme of things, her jacket on the floor may drive you crazy, but it probably isn't worth putting your relationship bank account in the red over. Be grateful for every single thing she does that you like, and you'll find her doing lots more of those things.

9. Commit to radical self-acceptance and compassion. Want to feel more love in your heart? Give it to yourself! Love is a verb. Yes, love can just happen – but we only make more (and feel more) by giving it away. And we can only give our children as much love as our own hearts can hold. Go ahead – stretch your heart. Every time you feel bad, for any reason, offer yourself love. You'll be amazed how your life transforms.

10. Keep Perspective. Sure, your kids will make mistakes, and so will you. There are no perfect parents, no perfect children, and no perfect families. But there are families who live in the embrace of great love, where everyone thrives. The only way to create that kind of family is to make daily choices that take you in that direction. It's not magic, just the hard work of course correction to stay on the right path. But if you look for it, you can always find trail marks and support to beckon you onward to a more rewarding life. Just keep taking positive steps. Before you know it, you'll find yourself in a whole new landscape.

Your words carry amazing power. So when you speak make sure you uplift someone and never put them down.

Self-esteem in adolescence

By Charles Mak

'Self-esteem' is the container of an individual's emotional evaluation of his or her own worth.

Self judgment encompasses contradictory beliefs and emotions such as hope, fear, defeat, pride, despair, pride and shame.

"The self-concept is what we think about the self; self-esteem, is the positive or negative evaluations of the self, as in how we feel about it." Self-esteem is also known as the evaluative dimension of the self that includes feelings of worthiness, prides and discouragement. (Smith and Mackie)

Self-esteem and self-consciousness are closely associated. It is in fact seen as a sum of self-confidence (a feeling of personal capacity) and self-respect (a feeling of personal worth).

"The experience of being competent to cope with the basic challenges of life and being worthy of happiness." (Nathaniel Branden, 1969).

Self-esteem manifests itself as an implicit or inner judgment that every person develops of their ability to face the challenges of living, understanding and solving problems. The person's right to achieve happiness and to be given respect is also closely related to one's balance or deficiency in self-esteem.

In psychology, self-esteem plays a prominent role in understanding a person's behaviour. "There is no value-judgment more important to man—factor more decisive in his psychological development and motivation—than the estimate he passes on himself"(p.109).

How we value ourselves and how important we think we are affects our behaviour. It affects our thinking process, emotions, desires, values and goals.

Two aspects that affect self-esteem are self-confidence and self-respect. Depending on how we view ourselves determines our sense of efficacy and worthiness. Self confidence is the sense of right in choosing our goals and actions. It is how competent we believe we are in accomplishing and succeeding. Self-confidence is a way of motivation, having trust in ones knowledge and abilities.

Having confidence in the mind allows one to be capable to think. Without self-confidence is to live with doubt in efficacy. As a result, a person is ensnared by their own distrust, rendering themselves incompetent.

On the other hand, Self-respect is principles and values that allow us to make moral choices. It is our personal worth based on the standards we rate ourselves by. "every person judges himself by some standard; and the extent that he fails to satisfy that standard, his sense of worth, his self respect, suffers accordingly"(p.113).

Self-respect is a requirement because one has to act to gain values. In order to act, one has to appreciate the benefits of his actions. Therefore, a person must admire themselves and consider themselves worthy.

Self-esteem plays a crucial role during the adolescence stage when teenagers start to notice changes. Teenagers start to observe changes in their own environment, and in the outside world. During the adolescence stage one develops sexually and cognitively. Adolescents go through puberty, when one matures sexually.

A person going through puberty might notice changes in their reproductive organs and external genitalia. Adolescents also develop cognitively, developing a new level of social awareness and moral judgement.

Adolescence is a time of confusion, teens having to decide whether they want to stay in their own world, or escape to the outside world. In other words, they choose whether to become independent or dependent. These changes in their environment are sometimes confusing, because teenagers are different in the ways they cope with it.

Depending on how they cope with these adaptations, they form their own identities. The ways they handle these problems is a premonition on how they will manage themselves.

Coping with problems is involved in developing a teenager's self-esteem. In the early stages of development, children depended on their family for feedback. However, in the adolescence stage most teens find it discouraging to ask parents and peers for advice. This is because most teens find it embarrassing to speak to family, who are older and more experience, about puberty and their feelings.

On the other hand, it is common for them to listen to friends or someone they can relate to, rather than family and teachers. They can relate to their friends, who are on the same level and

share the same interest. Therefore, teens absorb the feedback of friends, which have an affect on their self-esteem.

In Stephen Glenn's "Raising Children for Success" lists seven characteristics of high-risk teens that have low self-esteem. Teens that have low self-esteem most likely have "weak perceptions of personal capabilities, significance and power or control in life". They also have "weak intrapersonal skills, lacking self-discipline and self-control". Furthermore, they bear "poor cooperation and communication skills".

Another characteristic is "weak systematic skills, little flexibility and integrity". And the last characteristic is "weak judgemental skills, having poor decision-making skills or support for personal values". These characteristics most often occur in "combination", and are interrelated. This is a serious problem, because these characteristics affect school performance.

Studies show that levels of self-esteem appear different in gender. Girls seem to have lower levels of self-esteem then boys. "Research has found that satisfaction with physical appearance is a large component of self-esteem, and adolescence girls have greater dissatisfaction with physical appearance then boys" (Harter,1990,1999).

A high self-esteem in adolescents often relates to positive values and principles. Positive self-esteem is most often associated with positive perception of parents. Also potential interest in a child's welfare, often results in positive self-esteem. Sometimes a teen's success in school and academic ability, during high school, predicts high self-esteem.

While researching self-esteem in adolescents, I surveyed high school adolescents about their self-esteem. Females ages

fourteen to seventeen seemed to have positive self-esteem. They were also very confident of their future goals. Four out of five thought peers and parents see them as a positive person.

The males, age's fifth-teen to seventeen, also seemed to think positive of themselves, but were unsure of their future goals. Furthermore, they thought peers see them as a positive person. On the other hand, they thought parents did not understand them.

During researching self-esteem, I notice my self-esteem during my teenage years relates to my identity and personality. How I feel about myself now is based on my experiences, especially during the adolescents' stage.

I found out that I have the same ways of solving problems, and reactions to problems. The most important fact is self-esteem develops with time and experience. It is prominent in the development of a person's identity

It is important to like oneself

As the child gets older and faces tough decisions — especially under peer pressure — the more self-esteem he or she has, the better.

Tell the child or the teenager that of course it's OK to have ups and downs in his or her feelings, but having low self-esteem isn't OK.

Feeling like one is not important can make one sad and can keep one from trying new things.

It can keep one from making friends or affect how hard you try at school.

If the child or teenager shows low self-esteem, advice him or her to try talking to an adult they trust about it. Tell the child that he or she may be able to help them come up with some good ideas for building their self-esteem.

Self-esteem can improve when the child or the teenager starts trying things they thought were too hard and then do well at them, or when a parent, family member, or other adult encourages them.

It is important to be patient, and help the child or teenager to get back on track.

When one starts to do well, self-esteem will skyrocket!

Part of growing up is learning to focus on your strengths and to accept and work on one's weaknesses — and that, in a nutshell, is self-esteem!

You may want to suggest to the child or the teenager the following to increase their self-esteem:

- Make a list of the stuff you're good at. It can be anything from drawing or singing to playing a sport or telling a good joke. If you're having trouble with your list, ask your mom or dad to help you with it. Then add a few things to the list that you'd like to be good at. Your mom or dad can help you plan a way to work on those skills or talents.

- Give yourself three compliments every day. Don't just say, "I'm so great." Be specific about something good about yourself, like, "I was a good friend to Jill today" or "I did better on that test than I thought I would." While you're at it, before you go to bed every night, list three things in your day that really made you happy or that you feel thankful for.

- Remember that your body is your own, no matter what shape, size, or colour it is. If you are worried about your weight or size, you can check with your doctor to make sure you're

healthy. Remind yourself of things about your body that are cool, like, "My legs are strong and I can skate really well."

- Remember that there are things about yourself you can't change. You should accept and love these things — such as skin colour and shoe size — because they are part of you.

- When you hear negative comments in your head, tell yourself to stop. Remind yourself of things you're good at and if you can't think of anything, ask someone else! You can also learn a new skill (for example, karate, dance, a musical instrument) so you can feel good about that!

By focusing on the good things you do and all your great qualities, you learn to love and accept yourself — the main ingredients for strong self-esteem!

Even if you've got room for improvement (and who doesn't?), knowing what you're good at and that you're valuable and special to the people that care about you can really help you deal with growing up.

Teenagers and self-esteem

By D'Arcy Lyness

Steve's mind wanders as he does his homework. "I'm never going to do well on this history test," he thinks. "My dad's right, I'm just like him — I'll never amount to much." Distracted, he looks down and thinks how skinny his legs are. "Ugh," he says to himself. "I bet the football coach won't even let me try out when he sees what a wimp I am."

Julio is studying for the same history test as Steve, and he's also not too fond of the subject. But that's where the similarity ends. Julio has a completely different outlook. He's more likely to think, "OK, history again, what a pain. Thank goodness I'm aching the subject I really love — math." And when Julio thinks about the way he looks, it's also a lot more positive.

Although he is shorter and skinnier than Steve, Julio is less likely to blame or criticize his body and more likely to think, "I

may be skinny, but I can really run. I'd be a good addition to the football team."

Self-Esteem Defined

We all have a mental picture of who we are, how we look, what we're good at, and what our weaknesses might be. We develop this picture over time, starting when we're very young. The term self-image is used to refer to a person's mental picture of himself or herself.

A lot of our self-image is based on interactions we have with other people and our life experiences.

This mental picture (our self-image) contributes to our self-esteem.

Self-esteem is all about how much we feel valued, loved, accepted, and thought well of by others — and how much we value, love, and accept ourselves. People with healthy self-esteem are able to feel good about themselves, appreciate their own worth, and take pride in their abilities, skills, and accomplishments.

People with low self-esteem may feel as if no one will like them or accept them or that they can't do well in anything.

We all experience problems with self-esteem at certain times in our lives — especially during our teens when we're figuring out who we are and where we fit in the world.

The good news is that, because everyone's self-image changes over time, self-esteem is not fixed for life. So if you feel that your self-esteem isn't all it could be, you can improve it.

Self-Esteem Problems

Before a person can overcome self-esteem problems and build healthy self-esteem, it helps to know what might cause those problems in the first place. Two things in particular — how others see or treat us and how we see ourselves — can have a big impact on our self-esteem.

Parents, teachers, and other authority figures influence the ideas we develop about ourselves — particularly when we're little kids. If parents spend more time criticizing than praising a child, it can be harder for a kid to develop good self-esteem. Because teens are still forming their own values and beliefs, it's easy to build self-image around what a parent, coach, or other person says.

Obviously, self-esteem can be damaged when someone whose acceptance is important (like a parent or teacher) constantly puts you down. But criticism doesn't have to come from other people. Some teens also have an "inner critic," a voice inside that seems to find fault with everything they do.

And people sometimes unintentionally model their inner voice after a critical parent or someone else whose opinion is important to them.

Over time, listening to a negative inner voice can harm a person's self-esteem just as much as if the criticism were coming from another person. Some people get so used to their inner critic being there that they don't even notice when they're putting themselves down.

Unrealistic expectations can also affect someone's self-esteem. People have an image of who they want to be (or who they

think they should be). Everyone's image of the ideal person is different.

For example, some people admire athletic skills and others admire academic abilities.

People who see themselves as having the qualities they admire — such as the ability to make friends easily — usually have high self-esteem. People who don't see themselves as having the qualities they admire may develop low self-esteem.

Unfortunately, people who have low self-esteem often do have the qualities they admire. They just can't see it because their self-image is trained that way.

Why Is Self-Esteem Important?

How we feel about ourselves can influence how we live our lives. People who feel that they're likeable and lovable (in other words, people with good self-esteem) have better relationships.

They're more likely to ask for help and support from friends and family when they need it. People who believe they can accomplish goals and solve problems are more likely to do well in school. Having good self-esteem allows you to accept yourself and live life to the fullest.

More Steps to Improving Self-Esteem

(You may want your child to read what follows with you)

Please, my love, don't cry, do not feel sorry for yourself...
I am here, to help you.

If you want to improve your self-esteem, here are some steps to start empowering yourself:

- Try to stop thinking negative thoughts about yourself. If you're used to focusing on your shortcomings, start thinking about positive aspects of yourself that outweigh them. When you catch yourself being too critical, counter it by saying something positive about yourself. Each day, write down three things about yourself that make you happy.

- Aim for accomplishments rather than perfection. Some people become paralyzed by perfection. Instead of holding yourself back with thoughts like, "I won't audition for the play until I lose 10 pounds," think about what you're good at and what you enjoy, and go for it.

- View mistakes as learning opportunities. Accept that you will make mistakes because everyone does. Mistakes are part of learning. Remind yourself that a person's talents are constantly developing, and everyone excels at different things — it's what makes people interesting.

- Try new things. Experiment with different activities that will help you get in touch with your talents. Then take pride in new skills you develop.

- Recognize what you can change and what you can't. If you realize that you're unhappy with something about yourself that you can change, then start today. If it's something you can't change (like your height), then start to work toward loving yourself the way you are.

- Set goals. Think about what you'd like to accomplish, then make a plan for how to do it. Stick with your plan and keep track of your progress.

- Take pride in your opinions and ideas. Don't be afraid to voice them.

- Make a contribution. Tutor a classmate who's having trouble, help clean up your neighbourhood, participate in a walkathon for a good cause, or volunteer your time in some other way. Feeling like you're making a difference and that your help is valued can do wonders to improve self-esteem.

- Exercise! You'll relieve stress, and be healthier and happier.

- Have fun. Ever found yourself thinking stuff like "I'd have more friends if I were thinner"? Enjoy spending time with the people you care about and doing the things you love. Relax and have a good time — and avoid putting your life on hold.

It's never too late to build healthy, positive self-esteem. In some cases where the emotional hurt is deep or long lasting, it can require the help of a mental health professional, like a counsellor or therapist. These experts can act as a guide, helping people learn to love themselves and realize what's unique and special about them. Self-esteem plays a role in almost everything you do. People with high self-esteem do better in school and find it easier to make friends. They tend to have better relationships with peers and adults; feel happier; find it easier to deal with mistakes, disappointments, and failures; and are more likely to stick with something until they succeed. It takes some work to develop good self-esteem, but once you do it's a skill you'll have for life.

How Parents Can Help

The emotional and relational needs of children and adolescents, when not met, may create low self-esteem and mortification affecting their personality and future lives. How can a parent help to foster healthy self-esteem in a child? These tips can make a big difference:

- Be careful what you say. Kids can be sensitive to parents' and others' verbal expressions.

- Remember to praise your child not only for a job well done, but also for effort. But be truthful. For example, if your child doesn't make the soccer team, avoid saying something like, "Well, next time you'll work harder and make it." Instead, try "Well, you didn't make the team, but I'm really proud of the

effort you put into it." Reward effort and completion instead of outcome.

- Sometimes, a child's skill level is just not there — so helping kids overcome disappointments can really help them learn what they're good at and what they're not so good at. As adults, it's OK to say "I can't carry a tune" or "I couldn't kick a ball to save my life," so use warmth and humour to help your kids learn about themselves and to appreciate what makes them unique.

- Be a positive role model. If you're excessively harsh on yourself, pessimistic, or unrealistic about your abilities and limitations, your kids might eventually mirror you. Nurture your own self-esteem and they'll have a great role model.

- Identify and redirect inaccurate beliefs. It's important for parents to identify kids' irrational beliefs about themselves, whether they're about perfection, attractiveness, ability, or anything else. Helping kids set more accurate standards and be more realistic in evaluating themselves will help them have a healthy self-concept.

- Inaccurate perceptions of self can take root and become reality to kids. For example, a child who does very well in school but struggles with math may say, "I can't do math. I'm a bad student." Not only is this a false generalization, it's also a belief that can set a child up for failure. Encourage kids to see a situation in a more objective way. A helpful response might be: "You are a good student. You do great in school. Math is a subject that you need to spend more time on. We'll work on it together."

- Don't find continuous faults and accuse the child in your care.

- Be spontaneous and affectionate. Your love will help boost your child's self-esteem.

- Give hugs and tell kids you're proud of them when you can see them putting effort toward something or trying something at which they previously failed. Put notes in your child's lunchbox with messages like "I think you're terrific!"

- Give praise often and honestly, but without overdoing it. Having an inflated sense of self can lead kids and teens to put others down or feel that they're better than everyone else, which can be socially isolating.

- Give positive, accurate feedback. Comments like "You always work yourself up into such a frenzy!" will make kids feel like they have no control over their outbursts. A better statement is, "I can see you were very angry with your brother, but it was nice that you were able to talk about it instead of yelling or hitting." This acknowledges a child's feelings, rewards the choice made, and encourages the child to make the right choice again next time.

- Create a safe, loving home environment. Kids who don't feel safe or are abused at home are at greatest risk for developing poor self-esteem. A child who is exposed to parents who fight and argue repeatedly may feel they have no control over their environment and become helpless or depressed.

- Also watch for signs of abuse by others, problems in school, trouble with peers, and other factors that may affect kids' self-esteem. Encourage your kids to talk to you or other trusted adults about solving problems that are too big to solve by themselves.

- Help kids become involved in constructive experiences. Activities that encourage cooperation rather than competition are especially helpful in fostering self-esteem. For example, mentoring programs in which an older child helps a younger one learn to read can do wonders for both kids. Volunteering and contributing to your local community can have positive effects on self-esteem for everyone involved.

- When promoting healthy self-esteem, it's important to not have too much or too little but "just enough." Make sure your kids don't end up feeling that if they're average or normal at something, it's the same as not being good or special.

Narcissism

Low self-esteem is often related to a narcissistic perception of the Self. Let's look at some definitions of narcissism.
1. inordinate fascination with oneself; excessive self-love; vanity.

Synonyms: self-centeredness, smugness, egocentrism.
2. Psychoanalysis: erotic gratification derived from admiration of one's own physical or mental attributes, being a normal condition at the infantile level of personality development.

Narcissism: Surviving the Self-Involved

An interview with Meredith Resnick by Irene S. Levine

When I heard that my colleague and fellow PT blogger, Meredith Resnick a writer and licensed clinical social worker, had recently published an e-book on the topic of narcissism, I thought the topic might be of interest to readers of this blog, especially those who suspect that someone around them, either a friend or family member, may have the disorder.
Irene: What led you to write your e-book on the topic of narcissism?
Meredith: I worked for two decades in healthcare, but it was through my personal journey in a few relationships that I began

to learn, really learn, about narcissism, and its damaging effects. I wanted to heal from the effects, and it took me some time and a concerted effort to sort out exactly what was going on.

There is a certain, convoluted, 'smoke-and-mirrors' aspect of the disease of narcissism, given all the projection that goes along with it. But once I began to understand and see the nuances, I felt my own healing from the relationships really take hold. I wanted to share what I'd learned to help other people who might be suffering from the same feelings I'd had (and others have had as well).

Irene: What are the hallmark signs of a narcissistic personality?

Meredith: There are several, but here I'll mention three. I associate lack of empathy with narcissism, but also understand that a person who is narcissistic might appear to "care." I've found, for me, it's been helpful to view the relationship as a whole, to look at patterns. For example, non-empathy might appear as little digs, as a protracted period of coldness followed by what appears to be warmth (followed by icy coldness, and so on).

Projection is another key sign, which includes relegating their own (typically negative) feelings onto you, claiming they belong to you and/or that you alone are responsible for them feeling this way. Another sign is a tendency to be exploitative in their relationships without even thinking about it, to get what they want in big and little ways.

Irene: Why do we often tend to miss these signs at first?

Meredith: It may be because people with narcissism can and do present themselves quite charmingly. They may be fun; the life of the party. Or, they may be sweet and helpful, focusing on you and how great you are. When the tide turns with such individuals, it can come as a shock. (Bear in mind there are many truly authentically nice, kind, wonderful people.

But with them, we won't experience the breach being discussed here. And when we experience the breach, we know it!) Or, it may be for entirely different reasons. If a person was surrounded by self-absorbed people early in their lives, it's possible that person developed a kind of blind spot to problems in their friendships, or maybe they keep choosing friends who demand lots of attention.

This might happen when an individual is not accustomed to keeping the focus on herself in a healthy way, and, so, finds friends who want her attention to be on them!

Irene: Is it possible to have a mutually supportive friendship with a narcissist or is the friendship doomed? Do narcissists ever change their stripes or do I simply need to walk away from a close friendship with a narcissist?

Meredith: To these questions I would suggest re-evaluating what the individual really means by "mutually supportive," and encouraging them to think about what they like about the relationship, and accepting it for what it is. Perhaps two people can still have fun together, but maybe other aspects of the relationship they are seeking need to be found or developed in other friendships.

Finding Professional Help

If you suspect your child has low self-esteem, consider getting professional help. Child and adolescent therapists and counsellors can help identify coping strategies to help deal with problems at school or home in ways that help kids feel better about themselves.

Therapy can help kids learn to view themselves and the world more realistically and help with problem-solving. Developing the confidence to understand when you can deal with a problem and when to ask for help is vital to positive self esteem.

Taking responsibility and pride in who you are is a sure sign of healthy self-esteem and the greatest gift parents can give to their child.

A Positive Image: Self-esteem

Self-esteem means you really like yourself, both inside and out. It refers both to how you look and what you believe in. This is also called "positive" or "high" self-esteem.

Sometimes it's easy to like who you are. You feel great when you pass a test, score a winning touchdown or tell a funny joke that everyone laughs at.

But how do you feel about yourself when you just said something stupid or fumbled the football?

You sometimes feel dumb or left out of the action. You start wishing you were someone else or that you could change how you look.

You think you aren't good in school, on the team or part of the cool crowd. This is "negative" or "low self-esteem.

Once again, why is self-esteem important?

As a teen, you now have more responsibility to choose between right and wrong. Your parents are no longer constantly by your side. Positive self-esteem gives you the courage to be your own person, believe in your own values and make a the right decision when the pressure is on.

Your friends can put a lot of pressure on you. You want to be part of a crowd. The crowd may be the "cool" crowd, the "jock" crowd, the "computer" crowd or the "brainy" crowd.

Belonging to a crowd is a part of growing up; it helps you learn to be a friend and learn about the world around you.

It's okay to want to be liked by others -- but not when it means giving in to pressure. Your friends are now making many of their own decisions. And their decisions may or may not be good for you.

It's never worth doing things that could hurt you or someone else. For instance, drinking alcohol or using other drugs, having sex before you are ready, joining a gang or quitting school can all lead to trouble.

How do you get it?

Be honest with yourself. Figure out your strengths and weaknesses. Don't beat yourself up over your weaknesses. Don't compare yourself to others. It's hard at times, but accept yourself.

Set realistic goals for yourself.
Try to get the most out of your strengths and do your best, without demanding unrealistic results of yourself.
Celebrate your achievements.
Trust your own feelings.
Take it one day at a time.
Do your best each day.

Consider what can happen if you give in to the wrong decision. Drinking and driving can lead to serious injury or death. Sex may lead to pregnancy and/or STDs/STIs (sexually transmitted diseases or infections) including AIDS.

Joining a gang may lead to illegal behaviour and even jail. Quitting school takes away your best chance to be successful

later in life. It is not always going to be easy to stick to your values, but you will be happier if you do.

Only you know what is best for you. When you value and respect yourself, it helps you avoid making a bad decision, which may affect the rest of your life.

If you need help, go to your parents, a favourite teacher or counsellor. They want to help you. Asking for help is not a sign of weakness -- it is a natural thing. You are never too old or too young to ask for help.

Is it easy to change your self-esteem?

No. It means taking some time to understand who you are -- what you like, don't like, feel comfortable with and what goals you have. This takes time and hard work. It's a lifelong process, but it's worth the effort!

Does self-esteem guarantee success?

Success on tests? Success playing sports? Success with friends? No, but if you keep trying and doing your best, you are a success. Remember, having positive self-esteem will help you to achieve what you want. But when you don't succeed, it helps to accept the situation and move on.

Does self-esteem mean being self-centered or stuck-up?
No. Kids who act this way usually are trying to pretend they are something they are not. In fact, they often have low self-esteem.

Can I help others feel good about themselves?

53

Yes. Don't put others down. Be patient with your friends and family when they fall short. We all make mistakes from time to time.

Teach adolescents how to maintain healthy self-esteem

By Carl E. Pickhardt

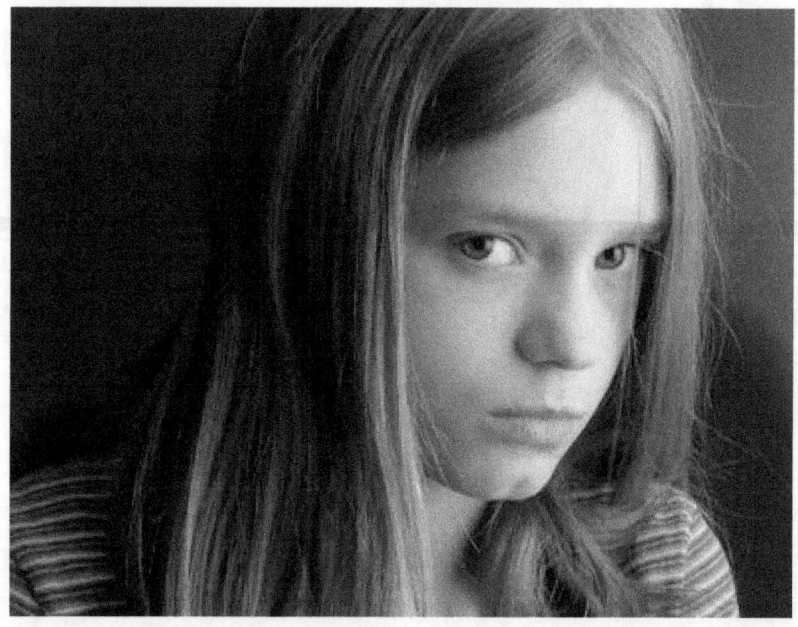

The concept of self-esteem is a very American one, particularly at home in our culture during the century that has followed its invention by psychologist William James.

Perhaps justified as part of our right to the pursuit of happiness and self-fulfilment, rooted in our emphasis on individualism, and nourished by our belief in self-improvement and material success, self-esteem is a notion that seems here to stay.

In addition, it has a certain common sense appeal and validity, if not a scientifically verifiable one. Given a choice, most people would rather have high self-esteem than low because they link it to personal well being and effectiveness.

From my view in family counselling, self-esteem can have significant impact on relationships. It generally seems that family members are more prone to act badly toward each other when they are feeling bad about themselves.

The worse they feel about themselves, the worse they often treat others, the worse they get treated in return, the worse they end up feeling about themselves, the worse they treat others, and round and round the cycle of unhappiness goes. In low-esteem families, relationships can become mutually destructive.

In high esteem families, however, the reverse seems more likely to occur. The better family members feel about themselves, the better they treat each other, the better they get treated in return, the better off everyone tends to become. In high esteem families, relationships can become mutually affirming. Members seem more inclined to bring out the best in each other, not the worst.

So positive self-esteem is not some kind of popular fad or new-age frill. Upon its existence, the happy and healthy functioning of individuals and families partly depend, particularly during children's teenage years.

I have seen two major self-esteem drops during the normal course of adolescence.

The first drop occurs at the outset in early adolescence (ages 9-13) when the young person's separation from childhood creates

a loss of contentment with being defined and treated any longer as just a child.

In this process, many components of self-definition now considered "childish" - beloved interests, activities, and relationships that supported self-esteem - may be sacrificed for the sake of future growth and acting older.

A lot of "kid stuff" of significant psychological value can be thrown away. Old toys and hobbies can be abandoned, and even cherished grandparents can be put at a distance.

The second drop in self-esteem occurs during the end of adolescence, trial independence (ages 18-23), when the young person is confronted with the daunting reality of independence and feels overwhelmed and diminished by the future shock mentioned in my previous blog.

Feeling not up to this challenge and sometimes acting this way, it is easy to feel disappointed in them selves, to get down on them selves, and even to punish them selves, esteem falling in the process. "Here I am 22 years old, still messing up, and I can't get my life together!"

So what is self-esteem? It is not real in the sense that it can be visually examined, physically touched, or directly observed.

Similar to notions like 'intelligence' or 'conscience', self-esteem is an abstract psychological concept made up to describe part of a person's human nature. It's existence and utility is inferred through actions and expressions considered evidence of its presence.

Just as solving a problem may be considered evidence of intelligence, or acting in accord with one's ethical beliefs may

be considered evidence of conscience, insisting on being dealt with fairly or respectfully may be considered evidence of self-esteem, the young person acting as though they are worth treating well.

More specifically, "self-esteem" is two words compounded into one. Separate them, and the meaning of the larger term comes clear. "Self" is a descriptive concept: By what specific characteristics do I identify who I am? "Esteem" is an evaluative concept: How do I judge the value of who I am?

Self-esteem has to do with how a person identifies and evaluates his or her definition of self.

Start with self-esteem as identification. When the adolescent commits his or her identity to just one part of life - to having friends, to competitive sports, to high academic achievement - then when friends are lost, when injury ends athletics, when academic performance drops, esteem comes crashing down. "I'm nothing without my friends!" "I'm worthless without my sport!" "I'm a failure if I don't make an A!"

To maintain relative constancy of well being through the normal ups and downs of adolescence, it really helps to have multiple pillars of self-esteem.

Consider self-esteem as evaluation. When the adolescent is routinely hard on him or herself - from insisting on excellence, from criticizing failings, from punishing mistakes - then when expectations are unmet, when imperfections become apparent, when human errors occur, esteem comes crashing down. "I'm so stupid!" "What's wrong with me!" "I can't do anything right!" To maintain constancy of well being during the trials of adolescence, it really helps when life goes badly to treat oneself with tolerance and understanding.

Particularly in the response to a bad experience where impulsive or unwise decision making led to error, disappointment, or trouble, an adolescent can get into some pretty harsh self-evaluation, descending common steps that systematically lower self-esteem. They are:

Should your son or daughter proceed to beat up on themselves for choosing unwisely or for life going badly, you might suggest this to them: "To hurt yourself when you are already hurting only makes the hurt worse. When you're hurting is a time not to treat yourself badly, but well. That way you can motivate yourself to do better."

So what might you say to your adolescent about self-esteem? "The more narrowly you define yourself and the more negatively you evaluate yourself, the more at risk of lowered self-esteem you are likely to be. In that unhappy state, you may also be more at risk of treating yourself and others badly.

Therefore, do yourself a favour. To maintain positive self-esteem, define yourself broadly and evaluate yourself kindly and most of the time you will appreciate the value, and enjoy the company, of who and how you are."

Is there such a thing as having too much self-esteem? Yes. People who prize themselves too highly often believe they are superior, are always right, are owed special consideration and treatment, need allow no disagreement, know it all (or at least all worth knowing), deserve be given their way, and should be allowed to rule over the lives of others.

Many tyrants, petty and great, from the entitled child to the cruel despot, have had extremely high self-esteem -- to other people's cost.

Within the matrix of concepts that explain psychological functioning, I believe self-esteem has a useful place. Important as it is, however, strong self-esteem is not everything.

For example, it is independent of morality. Strong self-esteem does not prevent wrongdoing. People who feel extremely positive about who and how they are can still become bullies, criminals, and even destructive zealots. Evil can claim strong self-esteem as easily as can good.

Self-esteem is also independent of outcome. It does not assure accomplishment. People who feel confident about performing well are still capable of making misunderstandings, miscalculations, and mistakes. Strong self-esteem can lead a person into failure as well as to success.

My favourite prescription for preserving strong self-esteem was reported in the New York Times a number of years ago (September 28, 1999, p. C31.) "There's a lot of talk about self-esteem these days...It seems pretty basic to me. If you want to feel proud of yourself, you've got to do things you can feel proud of. Feelings follow actions.

Quoted from "Surviving Your Child's Adolescence" (Wiley, 2013.)

6 Tips to Improve Self-Esteem

(You may want to ask the child in your care to read and share his or her opinions with you on this article)

by John M. Grohol

Young people are often confused about what it means to have self-esteem. Some think it has to do with the way you look or how popular you are with your friends or others.
Others believe that having a great body will help you gain self-esteem, while others think you actually need to have accomplished something in order to have good self-esteem.
Boiled down to its simplicity, self-esteem simply means appreciating yourself for who you are — faults, foibles and all.

It seems like other cultures don't grapple with self-esteem as much as Americans do, perhaps because of the emphasis we seem to put on materialistic indicators of self-worth (like what kind of car you drive, what school your kids attend, what your grades are, how big a house you have, or what your title is at work).

The difference between someone with a healthy or good self-esteem and someone who doesn't isn't ability, per se. It's simply acknowledgement of your strengths and weaknesses, and moving through the world safe in that knowledge.

Which brings me to the question I'm often asked — how can I increase my self-esteem? Here's how.

People with a good and healthy self-esteem are able to feel good about themselves for who they are, appreciate their own worth, and take pride in their abilities and accomplishments.

They also acknowledge that while they're not perfect and have faults, those faults don't play an overwhelming or irrationally large role in their lives or their own self-image (how you see yourself).

Take a Self-Esteem Inventory

You can't fix what you don't know. This is one of the core components of cognitive-behavioural therapy (CBT). Before you get to work on putting CBT to work, you have to spend a fair amount of time identifying irrational thoughts and whatnot.

The same is true for your self-esteem. To simply generalize and say, "I suck. I'm a bad person. I can't do anything." is to tell yourself a simple but often convincing lie. I'm here to tell you that it's not true. We all suck from time to time. The solution isn't to wallow in suck-age as the core of your identity, but to acknowledge it and move on.

Get a piece of paper. Draw a line down the middle of it. On the right-hand side, write: "Strengths" and on the left-hand side, write: "Weaknesses." List 10 of each. Yes, 10. That may seem like a lot of the Strengths side if you suffer from poor self-esteem, but force yourself to find all 10.

If you're having difficulty coming up with a whole 10, think about what others have said to you over the years. "Thanks for listening to me the other night when all I did was talk your ear off!" "You did a great job at work with that project, thanks for pitching in." "I've never seen someone who enjoyed

housework as much as you do." "You seem to have a real knack for telling a story."

Even if you think the Strength is stupid or too small to list, list it anyway. You may be surprised at how easy it is to come up with all 10 when you approach it from this perspective.

This is your Self-Esteem Inventory. It lets you know all the things you already tell yourself about how much you suck, as well as showing you that there are just as many things you don't suck at.

Some of the weaknesses you may also be able to change, if only you worked at them, one at a time, over the course of a month or even a year.

Remember, nobody changes things overnight, so don't set an unrealistic expectation that you can change anything in just a week's time.

Set Realistic Expectations

Nothing can kill our self-esteem more than setting unrealistic expectations. I remember when I was in my 20s, I had thought, "I need to be a millionaire by the time I'm 30 or I'm going to be a failure." (Don't even get me started about how many things are wrong with that statement.)

Needless to say, 30 came and I was nowhere close to being a millionaire. I was more in debt than ever, and owning a home was still a distant dream. My expectation was unrealistic, and my self-esteem took a blow when I turned 30 and saw how far away such a goal was.

Sometimes our expectations are so much smaller, but still unrealistic. For instance, "I wish my mom (or dad) would stop criticizing me." Guess what? They never will! But that's no reason to let their criticism affect your own view of yourself, or your own self-worth. Check your expectations if they keep disappointing you. Your self-esteem will thank you.

This may also help you to stop the cycle of negative thinking about yourself that reinforce our negative self-esteem. When we make set realistic expectations in our life, we can stop berating ourselves for not meeting some idealistic goal.

Set Aside Perfection and Grab a Hold of Accomplishments… and Mistakes.

Perfection is simply unattainable for any of us. Let it go. You're never going to be perfect. You're never going to have the perfect body, the perfect life, the perfect relationship, the perfect children, or the perfect home.

We revel in the idea of perfection, because we see so much of it in the media.

But that is simply an artificial creation of society. It doesn't exist. Instead, grab a hold of your accomplishments as you achieve them.

Acknowledge them to yourself for their actual value (don't devalue them by saying, "Oh, that? That's just so easy for me, no big deal.").

It may even help to keep a little journal or list of things you accomplish. Some people might even do this on a day-by-day basis, while others might feel more comfortable just noting them once a week or even once a month.

The key is to get to your smaller goals and move on from each one, like a connect-the-dots game of life. It's just as important to take something away from the mistakes you make in life.

It doesn't mean you're a bad person, it simply means you made a mistake (like everyone does).

Mistakes are an opportunity for learning and for growth, if only we push ourselves out of the self-pity or negative self-talk we wallow in after one, and try and see it from someone else's eyes.

Explore Yourself

"Know thyself" is an old saying passed down through the ages, to encourage us to engage in self-exploration. Usually the most well-adjusted and happiest people I meet are people who have gone through this exercise. It isn't just about knowing your strengths and weaknesses, but also opening yourself up to new opportunities, new thoughts, trying out something new, new viewpoints, and new friendships. Sometimes when we're down on ourselves and our self-esteem has taken a big hit, we feel like we have nothing to offer the world or others. It may be that we simply haven't found everything that we do have to offer — things we haven't even considered or thought of yet.

Learning what these are is simply a matter of trial and error. It's how people become the people they've always wanted to become, by taking risks and trying things they wouldn't ordinarily do.

Be Willing to Adjust Your Own Self-Image

Self-esteem is useless if it's based upon an older version of you that no longer exists. I used to be good at many things I'm no longer good at. I excelled in math while in high school, but couldn't do a calculus problem today to save my life. I used to think I was pretty smart, until I learned just how little I knew. I could play trombone pretty well at one point, but no longer.

But all of that's okay. I've adjusted my own beliefs about my self and my strengths as I go along. I've become a better writer, and learned more about business than I ever knew before.

I don't sit around and say, "Geez, I really wish I could play trombone like I used to!" (And if I cared enough to really think that, I would go and take some lessons to get good at it again.) Instead, I evaluate myself based upon what's going on in my life right now, not some distant past version of me. Keep adjusting your self-image and self-esteem to match your current abilities and skills, not those of your past.

Stop Comparing Yourself to Others

Nothing can hurt our self-esteem more than unfair comparisons. Joe has 3,000 Facebook friends while I only have 300. Mary can outrun me on the field when we play ball. Elizabeth has a bigger house and a nice car than I do. You can see how this might impact our feelings about ourselves, the more we do this sort of thing.

I know it's tough, but you need to stop comparing yourself to others.

The only person you should be competing against is yourself. These comparisons are unfair because you don't know as much as you think you do about these other people's lives, or what it's really like to be them.

You think it's better, but it may be 100 times worse than you can imagine. (For instance, Joe paid for that many friends; Mary's parents have had her in sports training since she was 3; and Elizabeth is in a loveless marriage that only appears to be ideal.*)

I know I made this all sound easy. It's not. Changing your self-esteem takes time, trial-and-error, and patience on your part. Make an effort to be more fair and more realistic with your own self, however, and I think you may be pleasantly surprised by the results!

<center>Good luck!</center>

13 More Tips to Building Self-Esteem

> "I think that the best thing we can do for our children is to allow them to do things for themselves, allow them to be strong, allow them to experience life on their own terms, allow them to take the subway...let them be better people, let them believe more in themselves."
>
> ~ C. JoyBell C.

(You may want to ask the child in your care to read and share his or her opinions with you on this article)

By Jae Song & Tina Su

"People with high self-esteem are the most desired, and desirable people in society."
~ Brian Tracy

Can you recall the last time you were in an emotional slump, such that your beliefs in yourself and your abilities were slipping away?

How can we maintain the beliefs we have in ourselves, such that we can live with less anxiety and more joy?

Just imagine the things we would accomplish if we had the belief that we could do absolutely anything, especially if we could maintain a level of self-esteem that no circumstance could shake.

What would you be doing?

Self-esteem comes from positive self-imaging, and it is something that we proactively build for ourselves. Self-esteem doesn't happen while we wait passively.

When we leave it up to external factors, we build our self-esteem on sandy ground. What we want is a rock-solid foundation, and this only comes from building it within.

Throughout our daily routines, our minds are very good at picking up all the things we've done wrong, and it makes sure we are aware of them.

With such a counter-productive force at work, we can benefit greatly by regularly working towards establishing and building our own self image.

I've learned that the way we view ourselves directly affects everything we do.

People with high self-esteem get along easily with others, rarely get sick, and seem to have high energy reserves.

Also, their high level of self-esteem corresponds with their high level of productivity, capacity of happiness and state of well-being.

A Personal Story

As a style coach, I (Jae) am my own boss – which is a blessing and a curse. Without a manager to report to, deadlines, or set schedules, I am responsible for enforcing these on myself – intrinsically. I must do these things if I want to achieve my professional goals, even though it can feel like a burden at times.

Last month, after several previous hectic months of intense work, I had fallen into a lull. Maybe you can relate with me... It started with a few missed to-do items, then failure to deliver on a few commitments. I could feel the self-disappointment building inside. I felt stressed.

I woke up each morning with the thought of making up for the previous day's failures, only to find myself failing once again. In this vicious cycle my work started to accumulate, and for days I needed to push back on obligations and commitments.

I felt the grip on my self-esteem slipping, and was now scrambling to hang on to the remaining scraps of what was left of it. I kept making excuses and rationalizations for why I wasn't getting stuff done, and as my integrity waned, I started to lose faith in myself and procrastinate even more.

This was me a month ago.

It has been a beautiful learning experience being able to observe myself in this state of mind, and ultimately learning how I overcame it.

Self-esteem = how much we like ourselves = level of self-dominion.

What is self-dominion? It is our ability to get ourselves to actually do, what we want ourselves to do; in other words, self-discipline and self-trust.

A person who has dominion over themselves has self-integrity – staying true to their words and commitments.

Every time we fail to listen to our inner voice, and do not take action in something that we need to, we lose trust with ourselves and our abilities. This lack of self faith continues to spiral downwardly as we flounder to fulfil more commitments.

Turning Point: How to Start Building Self-Esteem

Most of us are familiar with the concept of momentum. When we do something well, regardless of how small the task, we build positive energy and momentum, which can fuel other tasks on our list.

For example, if you have just washed all the dishes, mowed the lawn, and made calls to all of your clients, it will be easier for you – psychologically – to quickly move on to and complete the next task. You will have built the momentum necessary to getting things done, and you are simply riding on that energy and building on previous successes.

On the flip side, when we put off what we want to do or know we should do, we lose momentum, and more importantly, we lose trust in ourselves.

Another way to view this is to pretend we have a personal assistant. The better they perform on the tasks assigned to them, the more confident we will feel towards their abilities to handle responsibility. Gradually, we will assign more important tasks to them as trust is established. We now have faith in their abilities to follow through. We trust them.

Conversely, if our assistant procrastinates and misses deadlines regularly, we will lose faith in their abilities to follow through. We stop trusting them. We stop giving them tasks (at least the important ones), and we start to look for a replacement assistant.

Now, think of ourselves as our own assistant. The more we follow through with actions, the more confidence and trust we'll establish with ourselves. We will then gain faith in our ability to take on more tasks.

The small wins with ourselves, directly affect how much we like ourselves. Each time we successfully follow through, the experience becomes a building block towards a more positive self image.

In order to build your self-esteem, you must establish yourself as the master of your own life.

Every single minute of your life is a moment you can change for the better.

If you've been delaying some action for half the day, don't dwell on it or beat yourself up for it, shift your focus to the

present moment and what you can do right now. Start with the smallest or the most important task.

The following are tips to help build continuous upward momentum towards higher self esteem.

So, what next?

Here is the list of 13 more *Tips*

1. Start Small

Start with something you can do immediately and easily. When we start with small successes, we build momentum to gain more confidence in our abilities.

Each completed task, regardless of how small, is a building block towards a more confident you. What are some small actions you can take immediately to demonstrate that you are capable of achieving goals you've set for yourself? For example, clean your desk, organize your papers, or pay all your bills.

2. Create a Compelling Vision

Use the power of your imagination. Create an image of yourself as the confident and self-assured person you aspire to become.

When you are this person, how will you feel? How will others perceive you? What does your body language look like?

How will you talk? See these clearly in your mind's eye, with your eyes closed. Feel the feelings, experience being and seeing things from that person's perspective. Practice doing this for 10 minutes every morning.

Put on music in the background that either relaxes you, or excites you. When you are done, write a description of this person and all the attributes you've observed.

3. Socialize

Get out of the house or setup a lunch date with a friend. Socializing with others will give us opportunities to connect with other people, and practice our communication and interpersonal skills.

4. Do Something that Scares You

As with all skills, we get better with practice and repetition.

The more often we proactively do things that scare us, the less scary these situations will seem, and eventually will be rid of that fear.

5. Do Something You Are Good At

What are you especially good at or enjoy doing? Regularly doing things that you are good at reinforces your belief in your abilities and strengths. I (Tina) can be very efficient with completing errands or administrative work. Whenever I have a few hours filled with ways in which I've maximized my time, I feel highly productive and this boosts the confidence have in my abilities as an organized and efficient person.

6. Set Goals

According to a study done at Virginia Tech, 80% of Americans say they don't have goals. And the people who regularly write down their goals earn nine times as much over their lifetime as people who don't.

By setting goals that are clear and actionable, you have a clear target of where you want to be.

When you take action towards that goal, you'll build more confidence and self-esteem in your abilities to follow through.

7. Help Others Feel Good About Themselves

Help somebody or teach them something. When you help other people feel better about themselves and like themselves more, it will make you feel good about yourself. See what you can do to make others feel good or trigger them to smile. Maybe giving them a genuine compliment, helping them with something or telling them what you admire about them.

8. Get Clarity on Life Areas

Get clarity on the life area that needs the most attention. Your self-esteem is the average of your self-concept in all the major areas of your life. Write down all the major categories of your life, e.g., health, relationships, finance, etc.

Then rate yourself on a scale of 1-10 in each area. Work on the lowest numbered category first, unless they are all even. Each area affects the other areas.

The more you build up each area of your life, the higher your overall self-esteem.

9. Create a Plan

Having a goal alone won't do much. Get clarity on your action items.

One of the biggest reasons people get lazy is because they don't have a plan to achieve their goals.

They don't know what the next step is and start to wander off randomly. When you're baking a cake, it's a lot easier to follow a set of clear instructions, than randomly throwing ingredients together.

10. Get Motivated

Read something inspirational, listen to something empowering, talk to someone who can uplift our spirits, who can motivate us to become a better person, to live more consciously, and to take proactive steps towards creating a better life for ourselves and our families.

11. Get External Compliments

As funny as this point suggests, go find a friend or family member and ask them "What do you like about me?" "What are my strengths?" or "What do you love about me?"

We will often value other people's opinions more than our own. We are the best at beating ourselves up for things not done well, and we are the worst at recognizing what we've done well in.

Hearing from another person our strengths and positive qualities helps to build a more positive image of ourselves.

12. Affirmations & Introspection

Use affirmations, but in the right way. Some people think that when they're in a slump, using positive affirmations will help them get out of it. I love affirmations, but I've realized you have to use them in the right way.

Sitting on your couch and saying "I am highly motivated and productive" does nothing. Say something like "I am sitting here being very unproductive right now, is this the ideal me? What would be my best self?"

Your affirmations have to be the TRUTH. Once you're honest, take the first step towards doing the thing, no matter how small.

13. No More Comparisons

Stop comparing yourself to other people. Low-self esteem stems from the feeling of being inferior. For example, if you were the only person in the world, do you think you could have low-self esteem? Self-esteem only comes into the picture when there are other people around us and we perceive that we are inferior. Don't worry about what your neighbour is doing. Accept that it'll serve you more to just go down your own path at your own pace rather than to compare yourself. Pretend you're starting over and begin immediately with the smallest step forward.

Self-esteem comes from self-dominion. The more power you have in getting yourself to take the right actions, the more self-esteem you will have. Your level of self-esteem affects your happiness and everything you do.

The Secret to Self Loving: what should I do with my life?

By Lisa

(You can ask your son or daughter to read and share opinions on this article)

This past year, I have come to appreciate the power of truly loving myself. Most of my life, being alone was one of my biggest fears. I found myself in numerous relationships for the wrong reasons and ended up settling in ill-fitting 'partnerships'.

This deeply rooted fear and lack of understanding of myself caused the relationships to become my whole world; my focus of attention; my center. I would sacrifice my own goals for the other person. And, when the relationship collapsed, so did my sense of self.

Through much introspection, I realized the source of these failed relationships was myself. I realized that I didn't truly love or appreciate myself and had relied on external sources for love and approval. I decided to change. I had to overcome my fear of loneliness by finding independence and personal freedom.

Even since I found true appreciation for myself, the quality of relationships I have attracted has been phenomenal. I have discovered that the more I loved and understood myself, the less I feared being by myself, and the more healthier relationships I was able to attract into my life.

I started doing what I called "Dates with myself". Regardless my external relationship status, I would schedule time with myself. I would literally take myself out on a date and spend that time totally focused on myself. It's my time.

We spend so much time and energy focused on others that we forget to recharge the source of that energy. It is only when you are well that you can have the energy and internal resources to make a positive difference and help others. This is a simple, yet powerful concept that can dramatically improve your well-being, effectiveness and mental health.

Before attempting a 'date with yourself', here are a few things to keep in mind:

- Remove Disturbances – unplug your phone, power down the cell phone and blackberry, shut down the computer, turn off the tv.

Do not let your mind get distracted during your self-date. This is your time to just be with yourself.

- Being Solo – It's important that you are on your own. You can talk to strangers, and make new friends, but you are on the self-date to get acquainted with yourself, no one else. If you live with a partner, schedule it so he/she isn't home, or just take yourself out of the house.

If you have kids, find a sitter, or plan around when your kids are not at home. It's also important to realize that this time is a gift for yourself, and you should only be focused on your well-being.

- Schedule - Plan how long you would like your dates to last. Set a minimum time, and commit to focus on yourself for at least that time. I typically schedule 2-4 hour dates with myself.

- Communicate - if you are in a relationship, it's important to communicate what you are doing and it's benefits clearly with your partner. Not only do we get their support, but also avoid any misunderstandings or neglect.

Here are some ideas for 'dates with yourself'. You can intermix several activities below into one date:

Reading Date – Go to a trendy café or find a comfortable place at home and read something inspirational for an hour or more. Have some hot herbal tea, cut up some fruits or crackers with cheese. Fully enjoy the experience.

Forgive – Write on a journal or loose paper all the things you forgive yourself for. We tend to be very harsh on ourselves, and voluntarily blame ourselves internally for failures, failures of achievement, failures to action, etc. Take this time to forgive

yourself for all the harsh things said, for mistreatment of your health, etc.

- Gratitude – List out all the things in your life you are thankful for. This is my favourite thing to do.

- Admiration - List out all the things that others admire about you. What are some things they'd say that you are good at or have natural abilities towards? Notice that I wanted you to pretend to be another person looking at yourself. We tend to blank on this question when asking ourselves directly.

Musical Date – Take in a live concert after treating yourself to a healthy and satisfying meal. For example, every Thursday, I used to make myself a great raw vegetarian meal and then go to the Symphony.

Did you know that you could get cheap single tickets in the first 4 rows? In Seattle, it's $15 at Seattle Symphony. Most people are not aware of this. It's not advertised.

Another idea is going to a jazz club or a show. Talk to strangers when you are there. You'll find the experience much more rewarding.

Yoga or Meditation Date – Take a group yoga or meditation class at a local gym, community centre, or temple. I used to do drop in classes at YMCA. They are $10 a class for non-members. After class, jump into the Jacuzzi if there is one. Come home, enjoy a light meal and relax for the evening.

Outdoors Date – Go for a long walk in an area that interests you. Go to a park, go camping, go for a long drive. I like to spend an hour on Sundays walking through the 'pike place' market (local farmer's market) with my dog, Tommy.

I enjoy seeing all the tourists, fresh produce and the energy in the market. I also like to walk along the waterfront. It's a good idea to bring a book and some water with you. Wander without rushing.

Art & Culture - Go to an art gallery opening or a local museum. In Seattle, we have the art walk the first Thursday of every month where many galleries are open into the night. It's very festive and inspiring, and I especially enjoy the people watching.

Appendix

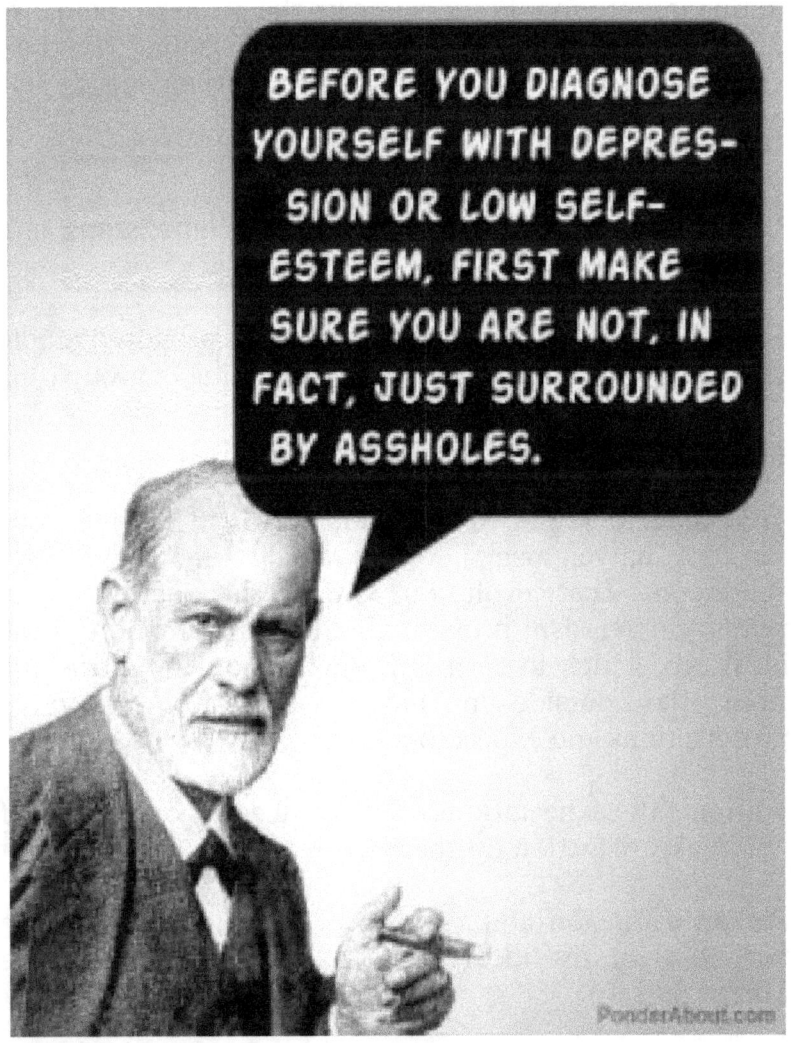

The importance and extensiveness of the topic...

In this last section, Freud sums up the principal points of "On Narcissism" and speculates on some of their implications for an understanding of human society. He recapitulates his discussions of the

 formation of the ego and the ideal ego,
 the role of narcissism in love, sexual relationships, and self-concept,

 and concludes by reflecting on how his proposed model of narcissism can inform our understanding of group .

The Formation of the Ego

According to Freud, we are not born with an ego; our sense of "having a self" evolves during infancy and early childhood. That evolution entails the disruption of primary narcissism brought about by the creation of the ideal ego, which in turn is brought about by intrusions from the outside--in most cases, from parental proscriptions and expectations.

Fulfilling the expectations of the ideal ego is one source of libidinal satisfaction for the ego.

For an extension and revision of Freud's theory of the formation of the ideal ego, see Jacques Lacan's "The Mirror Stage".

Narcissism in Love, Sexual Relationships, and Self-Concept

As the ego is developing, it is directing libido outward to objects (early on, to the mother, and later to other family members, people, and objects). Its narcissisim is depleted in this action, but is restored by the love returned to it by the objects of its love.

According to Freud, our self-concept (our sense of ourselves, including our confidence, our pride, and our sense of attractiveness to others) stems from three sources:

the residue of our original primary narcissism, which never fully disappears;
our fulfillment of the imagined expectations of our ideal ego (for example, our sense of being "virtuous";
the satisfaction we get when our love is returned to us.

Freud seems to imagine early infancy as a realm of existence in which what we desire is fully integrated into what we are, where there is no separation between ego- and object-libido. It is a return to this state, he claims, that we are striving for in our pursuit of happiness. Returning to his treatment of idealization, Freud suggests that since this ideal (an unattainable) condition is what we are looking for in our sexual and emotional lives, every object of our desire is idealized.

How we idealize our love objects may, in some cases, have to do with deficits in our own egos. If we feel we have lost a particular fine quality, or feel that we have never possessed it, we may look for it in those we love. Freud describes a particular problem that arises in cases

like these. A person suffering from a neurosis may attempt to regain narcissistic satisfaction by directing his or her love toward someone who represents the fulfilment of the neurotic's own ideal ego. Freud calls this "the cure by love," and reports that some patients leave analysis when they find a suitably ideal love-object, and continue their "therapy" in their relationship with that person. While Freud does not condemn such a solution, he cautions that it may well lead to the former patient's excessive dependence upon his or her partner.

Group Psychology

The final paragraph of the essay suggests that the theory of narcissism, and in particular the concept of the "ego ideal," is important for understanding group dynamics. Like individuals, groups have collective ideal senses of themselves, in which individuals of the group invest their own mental energies. Freud returns to his discussion of the repression of homosexual desire as a major component in the formation of the ideal ego. He suggests that the persistence of homosexual libido results in a pervasive sense of social guilt, which for him explains a number of features of mental illnesses such as paranoia and the paraphrenias. Here, as he does throughout the essay, Freud seems to take for granted the social prohibitions of his time. While he is quite open to the possibility of radical developments in science (recall his premonitions about the importance of genetics), he appears less able to imagine a social order in which gender and sexual relations take very different forms from the ones sanctioned in early-twentieth-century Vienna.

The discussion questions raise a number of issues about Freud's theory of narcissism as it concerns individual

development, gender identity and sexuality, and social organization.

An Adaptation Of Freud's Ego-Defense Mechanisms To Self-Esteem Issues

COMPENSATION: This is the process of masking perceived negative self-concepts, or of developing positive self-concepts to make up for the perceived negative self-concepts. For example, if you think you are an idiot you may work at becoming physically more fit than others to make up for this shortcoming.

DENIAL: This is the subconscious or conscious process of blinding yourself to negative self-concepts that you believe exist, but that you do not want to deal with. It is "closing your eyes" to the negative self-concepts about people, places, or things that you find too severe to deal with. For example, a family may pretend and act as if the father is only sick when it is obvious that he is an alcoholic.

DISPLACEMENT: This is when you express feelings to a substitute target because you are unwilling to express them to the real target. And the feelings expressed to the substitute target are based on your negative self-concepts about the real target. "Crooked anger" or "dumping" on another are examples of displacement. In these examples, you let out your anger and frustration about the negative self-concepts you are feeling about someone else on a safer target: such as someone below you, someone dependent on you, or someone under your control.

IDENTIFICATION: This is the identification of yourself with heroes, stars, organizations, causes, religions,

groups, or whatever you perceive as good self-concepts. This is a way to think of yourself as good self-concepts. For example, you may identify with a crusade to help starving children so that you can incorporate into your ego some of the good self-concepts associated with that crusade.

INTROJECTION: This is the acceptance of the standards of others to avoid being rated as negative self-concepts by their standards. For example, you may uncritically accept the standards of your government or religion in order to be accepted as good self-concepts by them.

PROJECTION: This is the attribution to others of your own negative self-concepts. This occurs when you want to avoid facing negative self-concepts about your behaviors or intentions and you do so by seeing them, instead, in other people. For example, you may be mad at your spouse and think, instead, that they are mad at you.

RATIONALIZATION: This is the process of explaining why, this time, you do not have to be judged as negative self-concepts because of your behaviors or intentions. It is sometimes referred to as "sour grapes" when, for example, you rationalize that you do not want something that you did not get because "it was lousy anyway." Rationalization can also take the opposite tack or what is sometimes referred to as the "sweet lemon." In this case, you justify, for example, an error in purchasing by extolling some of the insignificant good points of the product.

REACTION FORMATION: This is the process of developing conscious positive self-concepts in order to cover and hide opposite, negative self-concepts. It is the

making up for negative self-concepts by showing off their reverse. For example, you may hate your parents, but you go out of your way to show care and concern for them.

REGRESSION: This is the returning to an earlier time in your life when you were not so threatened with becoming negative self-concepts. You return to thoughts, feelings, and/or behaviors of an earlier developmental stage in order to identify yourself as you used to back then. For example, you may be being criticized as an adult and feeling horrible about it. And to escape this, you revert back to acting like a little child because you did not own criticism then as meaning you were negative self-concepts.

REPRESSION: This is the unconscious and seemingly involuntary removal from awareness of the negative self-concepts that your ego finds too painful to tolerate. For example, you may completely block out thoughts of killing a parent. This is not the same as suppression, which is also the removal from consciousness of intolerable negative self-concepts--but by conscious choice.

RITUAL AND UNDOING: This is the process of trying to undo negative self-concept ratings of yourself by performing rituals or behaviors designed to offset the behaviors that the negative ratings of you were based on. For example, a millionaire might give to charities for the poor to make up for profiting from the poor. Or, a parent may buy their child a lot of gifts to make up for not spending time with them.

SUBLIMATION: This is the process of diverting your feelings about the negative self-concepts that you have of

yourself or others into more socially acceptable activities. For example, if you generally hate people, you might be an aggressive environmental activist, an aggressive political activist, or join a fighting army. This way you can get some approval for the feelings that you disapprove of.

Bibliography

Baumeister, Roy F., Smart, L. & Boden, J. (1996). "Relation of threatened egotism to violence and aggression: The dark side of self-esteem." Psychological Review, 103, 5–33.
Baumeister, Roy F. (2001). "Violent Pride: Do people turn violent because of self-hate or self-love?," in Scientific American, 284, No. 4, pages 96–101; April 2001.
Crocker, J., & Park, L. E. (2004). "The costly pursuit of self-esteem." Psychological Bulletin, 130(3), 392–414.
Mruk, C. (2006). Self-Esteem research, theory, and practice: Toward a positive psychology of self-esteem (3rd ed.). New York: Springer.
Olsen, J.M., Breckler, S.J.,& Wiggins, E.C. (2008). Social Psychology Alive (1st ed.). Canada: Nelson.
Erol, R. Y., & Orth, U. (2011, July 4). Self-Esteem Development From Age 14 to 30 Years: A Longitudinal Study. Journal of Personality and Social Psychology. Advance online publication. doi: 10.1037/a0024299
Butler R.(1998. Age trends in the use of social and temporal comparison for self-developmental hypothesis. Child Development, 69, 1054-73.
Pomerantz E.M., Ruble, D.N., Frey, K.S.,& Grenlich, F. (1995). Meeting goals and confronting conflict:Children's changing perceptions of social comparison. Child Development, 66, 723-38.
Thorne, A., & Michaelieu, Q. (1996). Situating adolescent gender and self-esteem with personal memories. Cjild Development, 67, 1374-90.
Coopersmith, S. (1967). The antecedents of self-esteem. NewYork: W.H. Freeman.
Isberg, R.S., Hauser, S.T., Jacobson, A.M., Powers, S.I., Noam, G., Weiss-Perry, B., &Fullansbee, D. (1989). Parental

contexts of adolesecent self-esteem: Adevelopmental perspective. Journal of Youth and Adolescence, 18,1-23.
Lamborn, S.D., Mounts, N.S., Steinberg, L., & Dornbusch, S.M. (1991). Patterns of competence and adjustment among adolescents from authoritative, authoritarian, indulgent and neglectful families. Child Development, 62, 1049-65.
Leary, M. R., & Baumeister, R. F. (2000). The nature and fonction of self-esteem: Sociometer theory. In M. P. Zanna (Ed.),Advances in experimental social psychology (Vol. 32, pp. 1–62). San Diego, CA:Academic Press.
Crocker, J., Sommers, S. R., & Luhtanen, R. K. (2002). Hopes dashed and dreams fulfilled:Contingencies of self-worth and graduate school admissions. Personality and Social Psychology Bullentin, 28, 1275-1286.
Sedikieds, C., rudich, E. A., Gregg, A. P., Kumashiro, M., & Rusbult, C. (2004). Are normal narcissists psychologically healthy? Self-esteem matters. Journal of Personality and Social Psychology, 87, 400-416.
Baumeister, R. F., Smart, L., & Boden, J. M. (1996). Relation of threatened egotism to violence and aggression: The dark side of high self-esteem. Psychological Review, 103, 5-33.
Morf, C. C., & Rhodewalk, F. (1993). Narcissism and self-evaluation maintenance: Explorations in object relations. Personality and Social Psychology Bullentin, 19, 668-676.
Twenge, J. M., & Campbell, W. K. (2003). "Isn't it fun to get the respect we're going to deserve?" Narcissism, social rejection, and aggression. Personality and Social Psychology Bullentin, 29, 261-272.
Jordan, C. H., Spencer, S. J., & Zanna, M. P. (2003). "I love me...I love me not": Implicit self-esteem, explicit self-esteem and defensiveness. In S. J. Spencer, S. Fein, M. P. Zanna, & J. M. Olsen (eds.), Motivated social perception: The Ontario symposium (Vol. 9, pp. 117–145). Mahwah, NJ:Erlbaum.

Jordan, C. H., Spencer, S. J., Zanna, M. P., Hoshino-Browne, E., & Correll, J. (2003). Secure and defensive high self-esteem. Journal of Personality and Social Psychology, 85, 969-978.
Baldwin, M. W., & Sinclair, L. (1996). Self-esteem and "if...then" contingencies of interpersonal acceptance. Journal of Personality and Social Psychology, 71 1130-1141.

Further reading

Branden, N. (1969). The Psychology of Self-Esteem. New York: Bantam.
Branden, N. (2001). The psychology of self-esteem: a revolutionary approach to self-understanding that launched a new era in modern psychology. San Francisco: Jossey-Bass, 2001. ISBN 0-7879-4526-9
Burke, C. (2008)"Self-esteem: Why?; Why not?," N.Y. 2008 [1]
Franklin, Richard L. (1994). "Overcoming The Myth of Self-Worth: Reason and Fallacy in What You Say to Yourself." ISBN 0-9639387-0-3
Hill, S.E. & Buss, D.M. (2006). "The Evolution of Self-Esteem." In Michael Kernis, (Ed.), Self Esteem: Issues and Answers: A Sourcebook of Current Perspectives.. Psychology Press:New York. 328-333. Full text
Lerner, Barbara (1985). "Self-Esteem and Excellence: The Choice and the Paradox," American Educator, Winter 1985.
Maslow A. H. (1987). Motivation and Personality (3rd ed.). New York: Harper & Row.
Mecca, Andrew M., et al., (1989). The Social Importance of Self-esteem University of California Press, 1989. (ed; other editors included Neil J. Smelser and John Vasconcellos)
Rodewalt, F. & Tragakis, M. W. (2003). "Self-esteem and self-regulation: Toward optimal studies of self-esteem." Psychological Inquiry, 14(1), 66–70.

Ruggiero, Vincent R. (2000). "Bad Attitude: Confronting the Views That Hinder Student's Learning" American Educator.
Sedikides, C., & Gregg. A. P. (2003). "Portraits of the self." In M. A. Hogg & J. Cooper (Eds.), Sage handbook of social psychology (pp. 110–138). London: Sage Publications.
Twenge, Jean M. (2007). Generation Me: Why Today's Young Americans Are More Confident, Assertive, Entitled — and More Miserable Than Ever Before. Free Press. ISBN 978-0-7432-7698-6
Helge, D. (2012) "Conquer Your Inner Critic", Shimoda Publishing

97

Third Edition
2017

MASK PRESS OXFORD

www.ingramcontent.com/pod-product-compliance
Lightning Source LLC
Chambersburg PA
CBHW072228170526
45158CB00002BA/801